T0150589

THE WATSON GORDON
LECTURE 2010

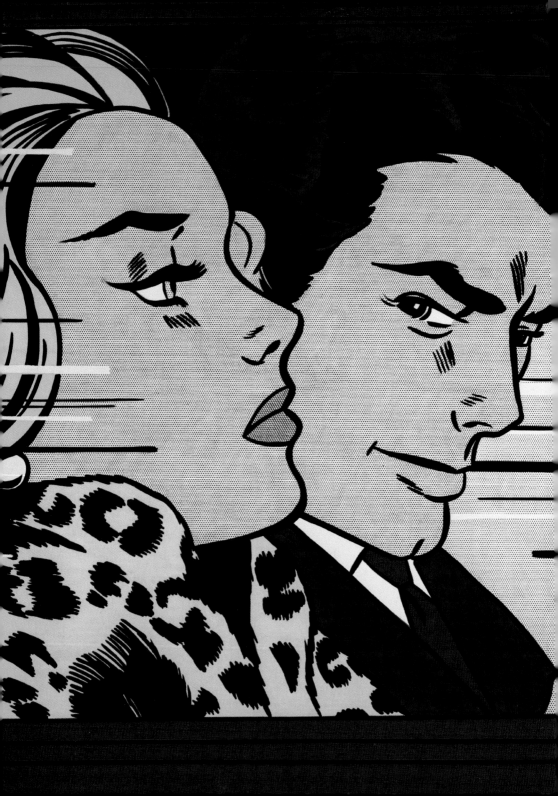

THE WATSON GORDON
LECTURE 2010

'The Hardest Kind of Archetype':
Reflections on Roy Lichtenstein

HAL FOSTER

NATIONAL GALLERIES OF SCOTLAND

in association with

THE UNIVERSITY OF EDINBURGH

and

VARIE

Published by the Trustees
of the National Galleries of Scotland, Edinburgh
in association with The University of Edinburgh and VARIE
© The author and the Trustees of the National Galleries of Scotland 2011

ISBN 978 1 906270 38 4

Frontispiece: detail from Roy Lichtenstein (1923–1997)
In the Car, 1963 (fig.11)
Designed and typeset in Adobe Arno by Dalrymple
Printed and bound on Hello Matt 150gsm
by OZGraf SA, Poland

FOREWORD

The publication of this series of lectures has roots deep in the cultural history of Scotland's capital. The Watson Gordon Chair of Fine Art at the University of Edinburgh was approved in October 1872, when the University Court accepted the offer of Henry Watson and his sister Frances to endow a chair in memory of their brother Sir John Watson Gordon (1788–1864). Sir John, Edinburgh's most successful portrait painter in the decades following Sir Henry Raeburn's death, had a European reputation, and had also been President of the Royal Scottish Academy. Funds became available on Henry Watson's death in 1879, and the first incumbent, Gerard Baldwin Brown, took up his post the following year. Thus, as one of his successors, Giles Robertson, explained in his inaugural lecture of 1972, the Watson Gordon Professorship can 'fairly claim to be the senior full-time chair in the field of Fine Art in Britain'.

The annual Watson Gordon Lecture was established in 2006, following the 125th anniversary of the chair. We are most grateful for the generous and enlightened support of Robert Robertson and the R.& S.B. Clark Charitable Trust (E.C. Robertson Fund) for this series which demonstrates the fruitful collaboration between the University of Edinburgh and the National Galleries of Scotland.

The fifth Watson Gordon Lecture was given by Hal Foster of Princeton University on 11 November 2010. Professor Foster is an acknowledged expert on modernist art and architecture, and has a particular fascination with Pop art. His wide-ranging lecture on Roy Lichtenstein is a gripping engagement with the multiple aspects of the artist's work: the conjunctions of art and technology, the satirical playing with previous modernist styles, and the sinister background of the military-industrial complex.

RICHARD THOMSON
Watson Gordon Professor of Fine Art,
University of Edinburgh

JOHN LEIGHTON
Director-General,
National Galleries of Scotland

ACKNOWLEDGEMENTS

I want to thank Richard Thomson and his colleagues at the University of Edinburgh and the National Galleries of Scotland who made my visit pleasurable and this publication possible. I also wish to dedicate this text to our mutual friend, Mark Francis, for our many conversations over the years on all matters Pop. HF

FIG.1 | ROY LICHTENSTEIN (1923–1997)
Washington Crossing the Delaware I, 1951
Oil on linen 66 × 81.3cm
Private collection

'THE HARDEST KIND OF ARCHETYPE': REFLECTIONS ON ROY LICHTENSTEIN

During the 1950s, in his apprenticeship as an artist, Roy Lichtenstein worked through various styles of twentieth-century painting, first along expressionistic lines, then in a faux-naif manner in which he adapted themes of Americana (as in *Washington Crossing the Delaware I*, fig.1), and finally in the abstract modes that preceded his Pop breakthrough. Lichtenstein experimented in similar ways in his early sculpture, which includes archaistic stone figures and primitivist wood assemblages. In the process he became adept in a wide range of modernist styles and devices, some of which, such as the gestural brushstroke, would soon reappear in his Pop work, but as second-hand – that is, as already processed, just as his motifs drawn from the cartoons, adverts, and comics are already processed.

It was harmless enough for Lichtenstein to stress that his print material was mediated beforehand; it was more controversial to imply, as he proceeded to do, that all artistic representations were already reproduced or otherwise screened – 'Parthenon, Picasso or Polynesian maiden,' as Richard Hamilton once put it, 'made as one before he touches them.'[1] Modernist forms of expression and abstraction were developed in part to resist the effects of mechanical reproduction; as though to underscore that even these forms could not be protected from this pressure, Lichtenstein focused his first Pop renderings of prior art there – in cartoonish reductions of print reproductions of various masters of expression and abstraction that he called 'idiot' versions.[2] Thus already in 1962 Lichtenstein began to produce parodies of Pablo Picasso in his Cubo-Surrealist phase (as in *Woman with Flowered Hat*, fig.2), and in 1964 he did the same with Piet Mondrian in his Neo-Plastic mode (as in *Non-Objective I* and *II*, fig.3). Yet perhaps his most pointed parodies in this respect are his series in 1968–9 after the *Rouen Cathedrals* (1892–4) and *Haystacks* (1890–1) of Claude Monet, in which the differentiated Impressionist brushstroke is replaced by the uniform Benday dot (fig.4). If the

FIG.2 │ ROY LICHTENSTEIN (1923–1997)
Woman with Flowered Hat, 1963
Magna on canvas 127 × 101.6cm
Private collection

FIG.3 | ROY LICHTENSTEIN (1923–1997)
Non-Objective I, 1964
Magna on canvas 142.9 × 121.9 × 3.8cm
Private collection

FIG.4 | ROY LICHTENSTEIN (1923–1997)
Rouen Cathedral (Seen at Three Different Times of Day), Set V, 1969
Oil and magna on canvas 160 × 106.7cm each
San Francisco Museum of Modern Art

Picasso and Mondrian parodies imply that mechanical reproduction had transformed the reception of what once seemed the most private and the most non-objective of modernist styles, the Monet parodies suggest that it had also qualified the very production of what once seemed the most immediate of modernist techniques, the one concerned to register optical sensation directly. The mechanical, Lichtenstein intimates, had worked its way into Monet – both technically in the repetition of his strokes and structurally in the seriality of his canvases – and he, Lichtenstein, simply diagrams what is already there.[3]

Lichtenstein applied his quasi-mediated dots, lines, and colours to motifs of his own invention, too, such as his first landscapes and sculptures, both of which date from the mid-1960s. In doing so he underscored that the world at large, natural as well as man-made, was no less subject than art to the effects of mechanical reproduction. His initial objects, ceramic female heads and coffee cups, appear to pop literally from his paintings of the same subjects of the early 1960s; and

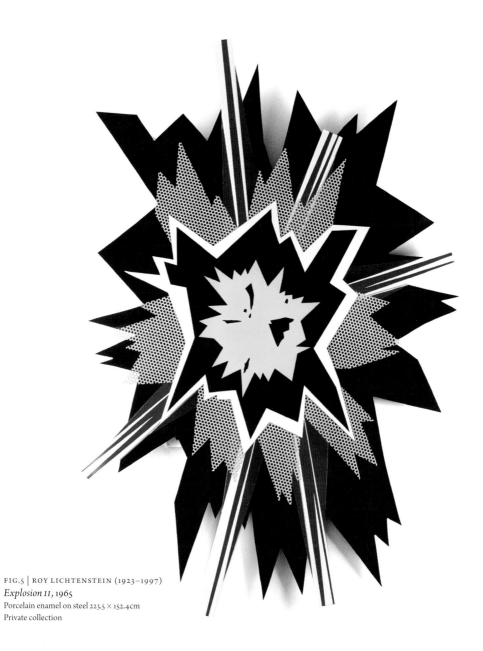

FIG.5 | ROY LICHTENSTEIN (1923–1997)
Explosion II, 1965
Porcelain enamel on steel 223.5 × 152.4cm
Private collection

most of his later objects also exist somewhere between painting and sculpture, as though caught between the condition of image and thing, or, more precisely, as though, even as things, they could not fight free of the virtual status of images. (His first 'Explosions' (fig.5), jagged shards of enamel and steel, which date from the mid-1960s, too, hyperbolise this hybrid state: as these cartoonish signs for various bursts move into three-dimensional space, they carry bits of two-dimensional imagery along with them.)[4] In this way, Lichtenstein implies, mechanical reproduction had not only confounded the definition of artistic mediums like painting and sculpture, but also transformed the appearance of everyday things like glasses, bowls, pitchers, and lights (such are the sculptural motifs that follow his early heads and cups). Thus, during the same time that Marshall McLuhan emerged as an apocalyptic prophet of a revolution in communication technologies, Lichtenstein also suggests that technological media have trumped artistic medium and that almost anything might be reformatted as an image.

Lichtenstein points to the causes of this change in general terms, too. 'In America,' he remarked in 1965, 'there's just more industrialization, and it permeates everyday life'; as a result, he added in 1967, there exists 'a new landscape for us [of] billboards and neon signs and all this stuff...to sell products'.[5] So, too, Lichtenstein points to the effects of this change, which he does not simply celebrate in his statements (here he should not be confused with his Pop peer Andy Warhol). In fact, in his early interviews Lichtenstein is explicit about the 'hard' and 'deadening' aspects of the culture; at the same time, he insists, these 'brazen and threatening characteristics...are also powerful in their impingement on us'; more, they 'give a kind of brutality and maybe hostility that is useful to me in an aesthetic way'.[6] This point is key to his practice, for implicit here is a strategy that goes beyond a provocative troubling of artistic oppositions (such as manual and mechanical modes of production) toward a critical redoubling of the lived conditions of consumer capitalism.[7] That is to say, what Lichtenstein intimates here is a mimetic troping of 'the brazen and threatening characteristics of our culture' – a mimesis of the industrial (he underscores the 'hard steely quality' of his work), the informational ('I want my painting to look as if it had been programmed'), and, of course, the commercial ('I got some of these colors from

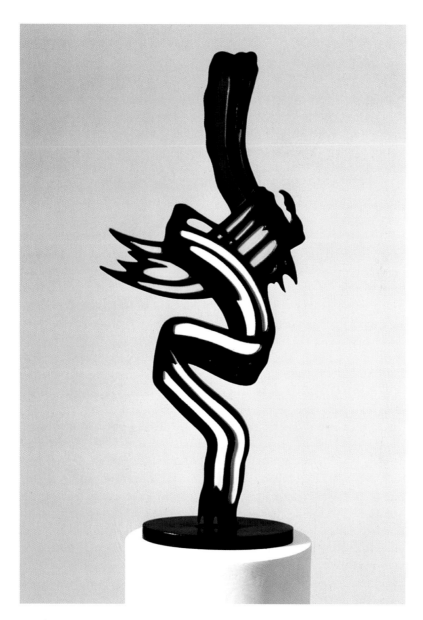

FIG.6 | ROY LICHTENSTEIN (1923–1997)
Brushstroke, 1981
Painted and patinated bronze 79.7 × 34.9 × 16.5cm
Private collection

supermarket packaging,' he remarked in 1971; 'I would look at package labels to see what colors had the most impact on one another').[8] I say 'mimetic troping' because his mimesis of the hard, programmed, and impactful is only part of his operation; just as important is his troping of these qualities, his turning of their 'powerful impingement' to his own ends.

In the consumerist world as sampled by Lichtenstein, even the devices and styles of modernist art have hardened into clichés. His primary figure of this hardening of devices is the gestural brushstroke: once a mark of subjective expression, Lichtenstein displays it as a congealed sign in his paintings of the 1960s and 1970s, and he shows it all the more fetishised when it doubles as an abstract nude in his sculptures of the 1980s and 1990s (fig.6). His primary instance of the hardening of styles is Cubism, a Cubism become 'hackneyed', even 'senseless', a Cubism stylised sometimes as Purism and sometimes as Art Moderne or Art Deco, as in *Modern Sculpture with Horse Motif* (1967).[9] This is a Cubism reduced to the commodified status of an objet d'art or a decorative ornament (his *Modern Sculptures* feature such characteristic Deco materials as brass, copper, aluminium mirror, tinted glass, and veined marble), which is perhaps why Lichtenstein often treats this style in sculptural form – though his objects, frequently in shallow relief and sometimes in trompe-l'oeil, are more pictorial than sculptural.[10] *Modern Head* (fig.7) is a particularly witty example. With positive and negative volumes in shallow relief, this profile in black chromed aluminium evokes a personage somewhere between a classical Mercury and a comic book superhero; at the same time it recapitulates the historical recuperation of both African figures and Cubist portraits in a chic version of streamlined Deco.

Lichtenstein is also drawn to other styles in which art converges with commercial design.[11] For example, in the early 1980s he makes a few sculptures after Constantin Brancusi, an artist who, despite his rhetoric of aesthetic purity, often approached the threshold of design (in an infamous case United States customs once held his *Bird in Space* (1927) for duty as a manufactured thing, a kitchen utensil in fact). With his own version of *Sleeping Muse* (1983) in patinated bronze – just a few inches deep, it is more outline than volume; its striated bars alone signify 'shading' and thus 'depth' – Lichtenstein pushes Brancusi across this decorative

[16]

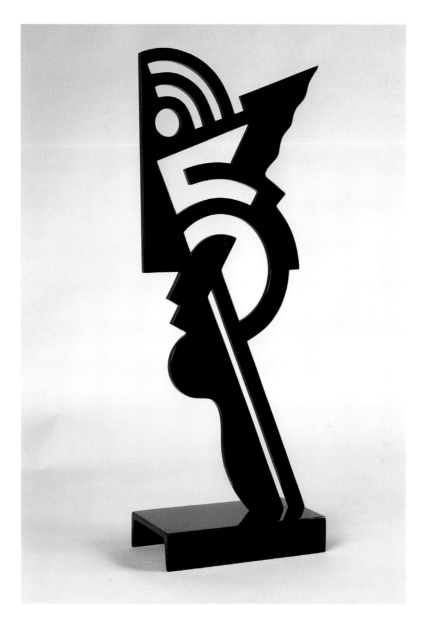

FIG.7 | ROY LICHTENSTEIN (1923–1997)
Modern Head, 1970
Black chromed aluminium 65.1 × 26 × 1cm
Location unknown

line. Sometimes, too, Lichtenstein alludes to Art Nouveau, a style in which the commingling of art and design is programmatic. Here an especially rich instance is *Surrealist Head* (fig.8), in which the florid curves of Art Nouveau are quoted to form the profile of the figure, the outline of her blonde hair and hat (or is it a parasol?), as well as the base of the piece. Walter Benjamin once read this 'mediumistic line-language' of Art Nouveau as a desperate attempt, deep into the industrial age, 'to win back the forms [of industry] for art'; yet here the appropriation runs in the other direction, art given over to industrial design.[12] The voluptuous line-language of Surrealism, the other style in play in this piece (again Lichtenstein favours the Picassoid version), might be seen as an equally desperate attempt to win back the forms of eroticism for art. However, as evoked in *Surrealist Head*, this contest, too, is lost: *Surrealist Head* is no more voluptuous than it is mediumistic (it is also far from uncanny in the Surrealist manner). If *Modern Head* suggests that the Cubist play with perception and signification had become hackneyed, *Surrealist Head* suggests that the Surrealist exploration of the erotic and the unconscious had become ornamental.

In fact Lichtenstein implies that no language, artistic or other, is immune from such reification. For example, the expressive utterances in his early romance paintings, even the onomatopoeic words in his early war paintings, are all so many clichés, reproduced for our camp appreciation.[13] And in his later sculptures Lichtenstein presents entire categories of art as generic – not only *Modern Sculpture* but also *Ritual Mask* (see fig.12), *Chinese Rock*, and *Amerind Figure* – as if they were so many listings in a design catalogue. (With its contraction of words 'Amerind' suggests a corporate brand, and with its abstraction of forms – part Northwest Coast Indian totem, part CBS logo – the 1981 sculpture so titled looks the part, too.) These rubrics conflate the most disparate of objects, styles, and practices, and none more so than his archaic heads (1988–9; fig.9), which evoke archaic styles from the Egyptian and the Minoan to the Etruscan, as well as modernist adaptations of these styles by artists like Gauguin and Picasso, only to condense all such allusions into one contoured stereotype (recall Hamilton: 'Parthenon, Picasso, or Polynesian maiden are reduced to the same kind of cliché')[14]. Beyond 'the museum without walls' initiated, according to André

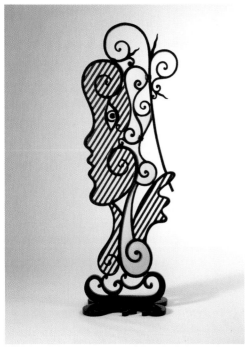

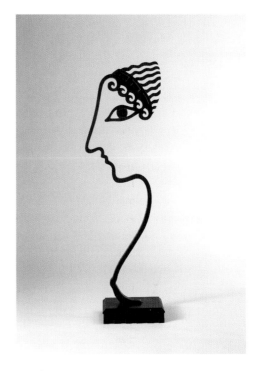

FIG.8 | ROY LICHTENSTEIN (1923–1997)
Surrealist Head, 1986
Painted and patinated bronze 200.7 × 71.1 × 44.1cm
Location unknown

FIG.9 | ROY LICHTENSTEIN (1923–1997)
Archaic Head VI, 1988
Patinated bronze 148.6 × 47.6 × 25.4cm
Private collection

Malraux, by photographic reproduction, what is suggested here is a mediation without limits, in which many diverse styles can be processed as one.[15]

One can draw a set of dire conclusions from this commingling of art and commercial design that Lichtenstein rehearses: that, by the moment of Pop, many avant-garde devices and modernist styles had become gadgets of the culture industry; that product and image, commodity and sign, were conflated, and that Pop paintings merely reiterate this structural equivalence; that, as a medium once uniquely suited to explore object relations, sculpture, too, was overridden by the commodity, whose effectivity Pop objects could only mimic; and so on.[16] Or one can take the benign view that both art and design often benefit from this exchange

of forms, and that traditional values of painting, such as unity of image and immediacy of effect, are updated in the process. In his most provocative doubling of all, Lichtenstein advances both views at once: his mimesis of 'brazen and threatening characteristics' points to the reification at work in his culture, even at the level of artistic devices and styles; at the same time his troping of these characteristics works to invent within this condition, and, in so doing, to mitigate it, if only a little, as well.

Here the crucial term for Lichtenstein is indeed 'the cliché', which the *Oxford English Dictionary* defines, in the first instance, as 'a metal casting of stereotype', and, in the second instance, as 'a hackneyed phrase or opinion' – a definition in the two registers, technical and rhetorical, that are most pertinent to Lichtenstein. 'He would tell me that he was most interested in European clichés,' his Rutgers colleague Allan Kaprow once remarked of Lichtenstein, 'that is, the kind of thing that becomes standard imagery.'[17] This standardness is again double: on the one hand, the cliché is reproduced to the point of utter familiarity, and as such, as Lichtenstein comments, it is 'completely antithetical to art'; on the other, its 'visual shorthand' suggests 'a kind of universal language', one that can possess a 'startling quality', in which case it involves 'an esthetic element' that can be developed.[18] It is this doubling in the cliché that Lichtenstein exploits.

The cliché also partakes of both terms in other doubles active in Lichtenstein – high and low art, abstract and iconic representation, and so on. Thus in his view the cliché is fundamental to 'classical' art and to cartoons alike. Consider this important comment made to the critic David Sylvester in 1966 when Lichtenstein was involved with his 'Brushstroke' paintings:

> I'm interested in … classical form, an ideal head for instance … Well, the same thing has been developed in cartoons. It's not called classical, it's called a cliché … I'm interested in my work's redeveloping these classical ways … I think that it's to establish the hardest kind of archetype that I can. There's a sort of formidable appearance that the work has when this is achieved … I think, really, that Picasso is involved in this. In spite of the fact that it seems as though he could do almost any kind of variation of any kind of eye or ear or head, there are certain ones that were powerful and strong because of the kind of symbolism that he employed.[19]

Note the relay here, permitted by this understanding of the cliché, among classical art, popular forms like cartoons, a modernist painting like Picasso's, and his own practice. 'Mine is linked to Cubism to the extent that cartooning is,' Lichtenstein commented in a related remark about his pictorial language to the critic John Coplans in 1967. 'There is a relationship between cartooning and people like Miró and Picasso which may not be understood by the cartoonist, but it definitely is related even in the early Disney.'[20] Here again Lichtenstein connects both mass and modernist styles to his own, implicitly via the cliché, and does so without the usual suggestion of corruption, co-option, or even compromise.

In some respects this notion of the cliché recalls the notion of the schema that, according to Ernst Gombrich in *Art and Illusion*, (a text Lichtenstein seems to have read shortly after its publication in 1960), guided the main trajectory of Western art toward ever more perfect representation. 'In that sense,' Lichtenstein said of the cliché in a 1962 conversation with another Rutgers colleague, Geoffrey Hendricks, 'it's like classical art, in that there's a classical eye or classical nose that gets redrawn,' and this schema is also operative in commercial art as well as in his own. Here is Lichtenstein again:

> *I think many people miss the central tendency of the work … I don't care what, say, a cup of coffee looks like. I only care about how it's drawn, and what, through the additions of various commercial artists, all through the years, it has come to be, and what symbol has evolved through both the expedience of the working of the commercial artists and their bad drawing, and the reproduction machinery that has gotten this image of a coffee, for instance, to look like through the years. So it's only the depicted image, the crystallized symbol that has arrived... We have a mental image of a sort of the commercialized coffee cup. It's that particular image that [I'm] interested in depicting. I'm never drawing the object itself. I'm only drawing a depiction of the object – a kind of crystallized symbol of it.*[21]

Yet why this interest in 'the crystallized symbol'? Certainly, as his comments suggest, Lichtenstein values the 'impact' of the cliché; this 'compelling' aspect compels him in turn.[22] Clearly, too, he is interested in its legibility across subcultures ('classical', commercial, modernist, and so on); it is this range that makes it appear 'archetypal'. More importantly perhaps, the cliché is a means for Lichtenstein to

play on these different idioms, 'hard' and 'formidable' though they often are, and invent with them.[23] Finally, Lichtenstein is drawn to the cliché for its artificiality; he works to use and to demonstrate this conventionality and, in doing so, to distance us a little from its power (here, among Pop peers, he is close to Hamilton in particular).[24]

This is to suggest that the cliché functions in Lichtenstein not only as a 'crystallized symbol' but also as a protean sign – another key double in his work. Consider his own example of the cliché as treated in *Cup of Coffee* (fig.10). The painting uses but one true colour, a dirty yellow, to establish the cup and the saucer as well as the wall behind them. However simple they appear, the other elements, the black and the white, are multivalent: the black signifies at once as tabletop, as shadow on the cup, and as coffee, while the white signifies as light both on the cup and on the surface of the coffee, where it might also evoke milk or cream. Together the two constitute the sign for rising steam, too, criss-crossing curves of black and white, which is precisely a cliché as described by Lichtenstein, with little resemblance to the actual phenomenon. *Cup of Coffee* has all the 'impact' of the crystallised symbol, yet, as Lichtenstein pulls it apart and puts it back together, we see the making of this effect and understand its artifice.

In *Art and Illusion* Gombrich notes a prime convention in the Western tradition of picture-making: 'We respond with perfect ease to the notion in which black lines indicate both the distinction between ground and figure and the gradations of shading that have become traditional in all graphic techniques.'[25] Lichtenstein often deploys this sign in both these ways – and in others as well. A band of parallel lines might signify 'motion' when arrayed horizontally, as in *In the Car* (fig.11), or 'window' or 'windshield' when disposed diagonally, as in the same painting; elsewhere such lines signify 'screen' or, if slightly curved, 'mirror'. As Rosalind Krauss has shown, this semiotic play was already active in Cubism, especially in the early collages and *papiers collés* of Picasso, and, as Michael Lobel has noted, the parallel with Lichtenstein is sometimes a suggestive parallel. Picasso might use fragments from the same newspaper page to signify, largely by position, either the material flatness of an object or the atmospheric depth of its surround; and often Lichtenstein deploys his dots in this double manner as well.[26] 'Dots

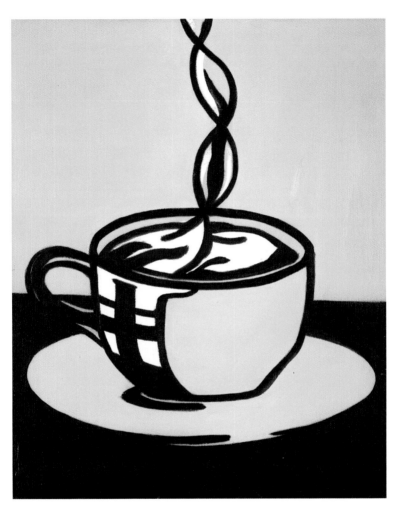

FIG.10 | ROY LICHTENSTEIN (1923–1997)
Cup of Coffee, 1961
Oil on canvas 51.1 × 40.6cm
The Roy Lichtenstein Foundation Collection

[23]

can mean printed surface and therefore "plane", Lichtenstein remarked to cura-
tor Diane Waldman in 1971, 'but in contradiction, particularly in large areas, they
become atmospheric and intangible – like the sky.'[27] Like Picasso, Lichtenstein
finds rich semiotic potential in poor material means.

Lichtenstein also turns inert stereotypes into active signs. Consider his early
insistence on the primary colours (he uses the occasional green, too): as in
Mondrian, his primaries evoke a non-natural world, but not a transcendental
one – they signal the 'readymade nature,' the second nature, of media. Moreover,
though his colours are not always arbitrary (yellow for blonde hair, for example,
or blue for fair sky), they do tend to signify differentially, relative to one another
(one patch in a painting might be yellow for no apparent reason other than other
patches are painted blue or red).[28] Thus in *In the Car* yellow is credible enough for
the woman's hair, but less so for her fur, and blue is credible enough for the man's
jacket, but less so for his hair. In comics and cartoons of the time, these clichés
were dictated by the technical limits of the printing process, but Lichtenstein
turns them to his advantage, and out of this commodified condition he produces
a semiotic charge, one not dependent on personal expressivity:

> *I got some of these colors from supermarket packaging. I would look at package
> labels to see what colors had the most impact on one another. The idea of contrast
> seemed to be what advertising was into in this case. An advertisement is so intensely
> impersonal! I enjoyed the idea that anything vaguely red like apples, lips, or hair
> would get the same red.*[29]

In his remarks on the cliché Lichtenstein does not mention African sculpture, yet,
as Yve-Alain Bois has demonstrated, Picasso and Georges Braque developed the
semiotic ambiguity of Cubist art in large part through their study of African masks.
Daniel-Henry Kahnweiler, the dealer of both artists at this moment, articulated
their insights as follows:

> *These painters turned away from imitation because they had discovered that the true
> character of painting and sculpture is that of a script. The products of these arts
> are signs, emblems, for the external world, not mirrors reflecting the external world
> in a more or less distorting manner. Once this was recognised, the plastic arts were
> freed from the slavery inherent in illusionistic styles. The masks bore testimony to*

[24]

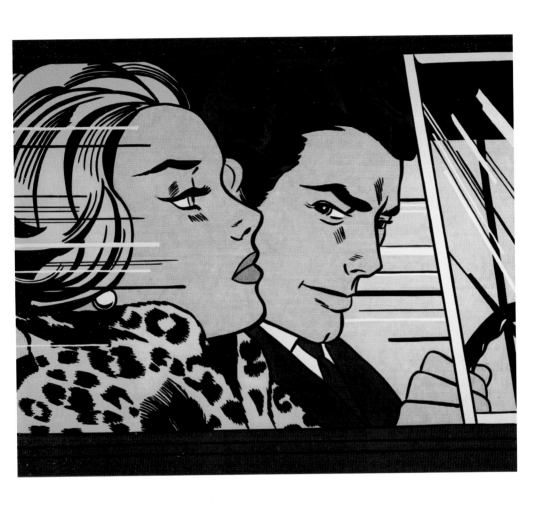

FIG.11 | Roy Lichtenstein (1923–1997)
In the Car, 1963
Magna on canvas 172 × 203.5cm
Scottish National Gallery of Modern Art, Edinburgh

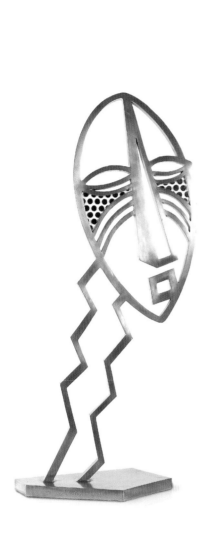

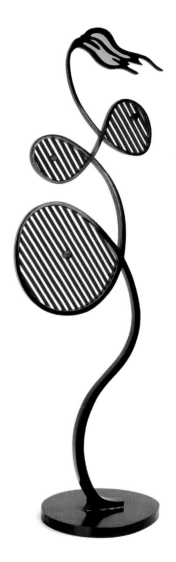

FIG.12 | ROY LICHTENSTEIN (1923–1997)
Ritual Mask, 1992
Painted and galvanised steel (varied metals) 130.2 × 55.9 × 28.9cm
Private collection

FIG.13 | ROY LICHTENSTEIN (1923–1997)
Galatea, 1990
Painted and patinated bronze 226.1 × 81.3 × 48.3cm
Metropolitan Museum of Art, New York

the conception, in all its purity, that art aims at the creation of signs. The human face 'seen', or rather 'read', does not coincide at all with the details of the sign, which details, moreover, would have no significance if isolated.[30]

Lichtenstein, too, aims at the creation of signs, as a script that is read as much as seen. Consider once more his *Modern Head* (see fig.7), which, again, evokes both African sculpture and Cubist art, even as it also suggests the reification of both in Art Deco. At the same time it engages semiotic ambiguity in a way that qualifies this reification.[31] Its entire profile can be taken as a simple head, if we read the circular hole near the top as its 'eye', or it can be seen as a head with a headdress or a helmet, in which the 'eye' becomes an ornamental element; as often with Picasso, this 'modern head' is at least two in one. Or consider a later example, *Ritual Mask* (fig.12), in which the Lichtenstein dots and stripes are punched holes and steel curves. In the context of 'mask' such details on the cheeks signify the scarification often represented in African masks as well as the modelling that the Cubists sometimes used these marks to evoke. However, 'if isolated', these details would 'have no significance', and the same is true of the sharp ovals signifying 'eyes', the nearly triangular piece signifying 'nose', and the nearly rectangular piece signifying 'mouth'. Like *Modern Head*, *Ritual Mask* snatches a semiotic dimension out of reified cliché – the hackneyed Cubism of Deco. In both instances the cliché-as-stereotype flips into the cliché-as-sign, and 'the hardest type of archetype' de-reifies before our eyes.

Paradoxically, then, the primary way that Lichtenstein mitigates reified appearance is through its exacerbation. 'It's another case of degrading the thing and then building it back up again,' Sylvester commented to Lichtenstein in 1966. 'You make a joke about it, but you make it dramatic again.'[32] Again, at the time of this conversation Lichtenstein was at work on his first 'Brushstroke' paintings, and though he inherits this gesture as a crystallised symbol, he also works to reanimate it. In his sculptures of the 1980s and 1990s, for example, he stands the brushstroke up, makes a figure of it, and, in such pieces as *Brushstroke* (see fig.6), endows it with a lively Pop contrapposto.[33] Indeed, Lichtenstein treats entire styles in this fashion, as we saw with his *Modern Sculptures*. By the 1960s Art Deco had become 'a discredited area', Lichtenstein remarked, 'like the comics'; however,

as such it acquired the uneasy effects of the *démodé*, as he also discerned: 'I am interested in the quirky results of those derivatives of Cubism and like to push this quirkiness further toward the absurd.'[34] This quirkiness is most evident in his 'idiot' versions of Picasso, whom Lichtenstein appropriates more often than he does any other artist, especially in the manner of the late 1920s and early 1930s, which combines the semiotic invention of Cubist forms with the 'peculiar maneuverability' of Surrealist figures.[35] In *Galatea* (fig.13), which displays his de-reifying energies as vitally as any work, Lichtenstein puts both qualities in play.

Galatea is a sinuous figure in a continuous line of painted bronze; it calls to mind how Picasso, for motives that were erotic as well as aesthetic, sometimes attempted to grasp his female bodies in a single trace, even though the process here is anything but immediate. Depending on size and location (that is, according to the semiotic principle pioneered by Picasso), three different oval areas in identical red stripes signify 'belly' and 'breasts', while three similar cylinders within these areas signify 'navel' and 'nipples'. Lichtenstein then tops his figure with a yellow brushstroke detailed in black that identifies her as a sprightly blonde, perhaps a lithe dancer on a stage or a bikinied girl on a beach. The Picasso that comes to mind is *Bather with Beach Ball* (1932), which was a talisman for Lichtenstein as early as *Girl with Ball* (fig.14). On the one hand, then, like these two bathers, *Galatea* might be seen as a late incarnation of the ancient nymphs that so intrigued the art historian Aby Warburg, who traced these recurrent spirits through 'the afterlife of antiquity' into modern visual culture; on the other hand, the sculpture is assembled from reified bits and pieces of received artistic styles and cartoonish signs.[36] On the one hand, *Galatea* is brought to life by her Pygmalion, Lichtenstein inspired by Picasso; on the other hand, no artist is more foreign than Lichtenstein to this classical myth about the immediacy of expression, the efficacy of touch, and the identity of art object and love object. Lichtenstein recovers aspects of the semiotic and the erotic in Picasso, even as he points to a reification already evident in his predecessor. At the dawn of the modernist era the young Karl Marx wrote: 'Petrified social conditions must be made to dance again by singing them their own song.'[37] Here as elsewhere Lichtenstein sings his own version of that song.

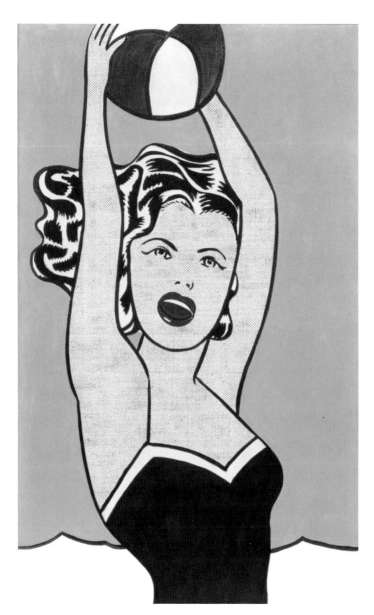

FIG.14 | ROY LICHTENSTEIN (1923–1997)
Girl with Ball, 1961
Oil on canvas 153.7 × 92.7cm
Museum of Modern Art, New York

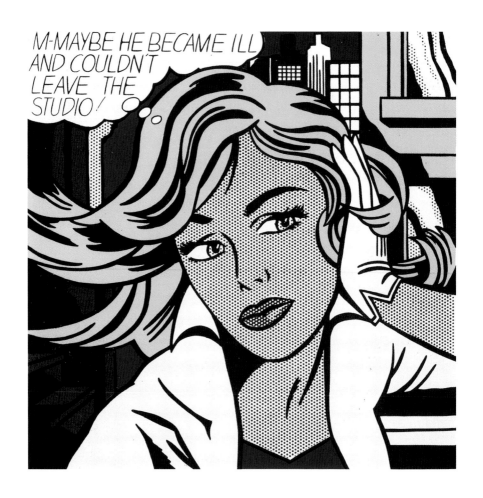

FIG.15 | ROY LICHTENSTEIN (1923–1997)
M-Maybe, 1965
Oil and magna on canvas 152.4 × 152.4cm
Museum Ludwig, Cologne

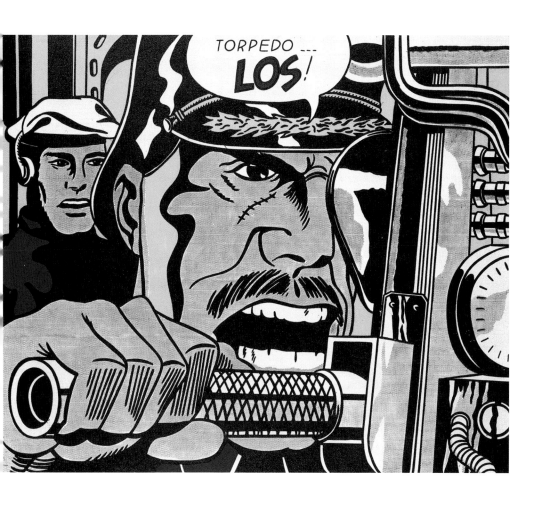

FIG.16 | ROY LICHTENSTEIN (1923–1997)
Torpedo… LOS!, 1963
Oil on canvas 172.7 × 203.2cm
Private collection

For all intents and purposes my argument ends here. But I feel I have not done justice to the painting, so I want to return to it briefly, in the form of a coda, and ask what are the subject-effects of this art of the cliché. What sorts of subject – portrayed, viewing, and producing – emerge in these images?

The charge of superficiality that first greeted Lichtenstein was also directed at his figures, which, derived from print materials, appear flat – psychologically as well as physically. In addition, the ones drawn from comic books often face the viewer frontally (this device both invites the reader to relate to the character and condenses as much narrative as possible in a single cell). As Lobel has noted, Lichtenstein tends to push his female figures in particular to the picture plane, where they are sometimes equated with pure image or sheer surface, as they frequently are in classic Hollywood cinema.[38] For Lichtenstein, however, this convention also bears on the actual self-presentation of stylish women. 'Women draw themselves this way,' he remarked in 1967 in a partial justification of his pictorial treatment of female figures, 'that is what makeup really is.'[39] Here Lichtenstein refers less to the artificiality of all maquillage than to the flatness of the Pop face (think of Edie Sedgwick or Twiggy, who emerged as a star model not long before this comment); in this account life copies art in a manner that Lichtenstein redoubles in his painting (fig.15).

In the 1960s these flat surfaces were taken as a sign of a cool sensibility, an affectless condition, which was associated with the culture of Pop, especially the Warhol scene. Affect is not absent from Lichtenstein – on the contrary – but it is relocated away from emotional depth toward melodramatic surface, from Action painting to action scenes of romance and war in the comics (fig.16). To a degree this is a campy move on his part, but it carries a serious proposition about postwar society, one that Hamilton also advances: that codes of femininity and masculinity are primarily learned from mass-cultural media, that subjects are socialised through such popular forms as comic books, adverts, magazine stories, and television shows, more than through any 'great tradition' of art and literature. At the same time, with the satirical streak in his paintings, Lichtenstein renders these codes comical; the stereotype of the passive woman lost in romance, say, or of the macho man bloodthirsty in war is inflated to an absurd point, to the point of deflation. 'The heroes

depicted in comic books are fascist types,' Lichtenstein commented in 1963, 'but I don't take them seriously in these paintings – maybe there is a point in not taking them seriously, a political point.'[40] In short, his artistic manipulations of his media sources introduce an element of *dis*identification into the very mechanisms of mass-cultural identification. At the same time Lichtenstein points to an important shift in the ground of subject-formation – a shift away from the old notion of a self-made ego (whether of the romantic or the existentialist type) toward a new view of the individual as structured by a symbolic order that precedes him or her. And in turn this view suggests a different project for the artist (one also proposed by Hamilton): to treat the artistic image as a mimetic probe to explore this given matrix of cultural languages – to take apart its clichés and to put them back together, with differences that, as Lichtenstein once remarked, are 'often not great' but may yet be 'crucial'.[41] If there is a critical dimension in Pop art, it lies here.

Here we pass from the portrayed subject to the viewing subject. Lichtenstein was very interested in the quickening of vision in this social period. One can see this as only another moment in the long history of the disciplining of the modern subject, yet this particular training had a special importance in the United States of the 1940s and 1950s, for heightened skills of visual recognition were essential to soldiers in the Second World War and the Korean War, especially pilots and gunners.[42] Here Lichtenstein drew from his own experience: in 1943 he was posted at Camp Hulen in Texas, an anti-aircraft training base, and in 1944 at Keesler Air Force Base in Mississippi, which specialised in pilot instruction. Nearly twenty years later, just as the American involvement in Vietnam had begun to deepen, he made aerial warfare a prominent theme of his paintings. What is key here, however, is not his biographical connection to this theme but his pictorial association between the visual acuity prepared by modernist art and the perceptual aptitude demanded by modern war.[43] Especially in his pictures of fighter pilots, submarine captains, and the like, Lichtenstein suggests that there is but a fine line between a 'pop' eye and a 'killer' eye; his paintings point to a shared speed, a shared aggressivity, in these ways of seeing.[44]

This seeing bears on consumerist vision, too. If his training was 'object-directed', as Lichtenstein once remarked, it was also product-inflected, for the apprehension

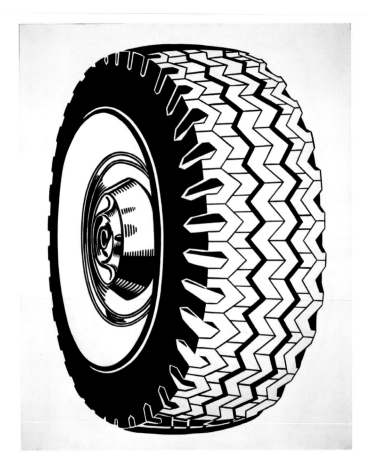

FIG.17 | ROY LICHTENSTEIN (1923–19?
Tire, 1962
Oil on canvas 172.7 × 142.2cm
Private collecton

FIG.18 | ROY LICHTENSTEIN (1923–19?
Standing Rib, 1962
Oil on canvas 53.3 × 63.5cm
Private collecton

of images as wholes (a prime goal of American art schools at the time) was essential to commodity identification, especially during the postwar boom in marketing.[45] Some of his early paintings of products, such as *Tire* (fig.17), play on this eidetic kind of consumerist recognition: usually presented starkly in black on white, these images already possess the graphic power of company brands and corporate logos. This points to the historical convergence between late-modernist painting and commercial design, and in this regard Lichtenstein saw

[34]

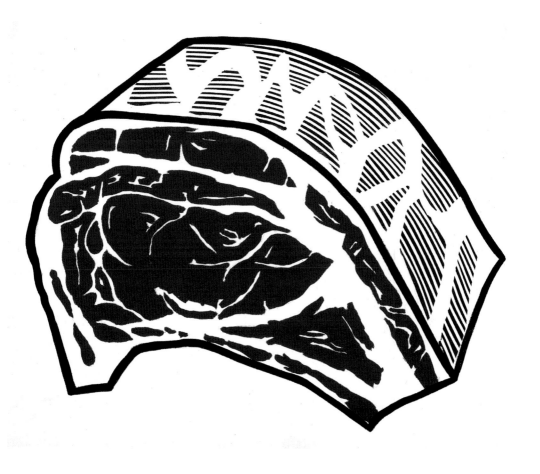

a link between his own work and contemporaneous abstraction: 'it's maybe the same kind of thing that you find in [Frank] Stella or in [Kenneth] Noland,' he remarked to Sylvester in 1965, 'where the image is very restricted'.[46] Here Lichtenstein aligns the impact of late-modernist painting with the impact of media images; both elicit a response that he elsewhere describes as 'immediate, not contemplative'.[47] In short, the implication is that a targeting subject has arisen in the military-consumerist complex of postwar America in a way that complicates,

if not negates, the contemplative subject of the traditional tableau as well as the transcendental subject of the modernist painting.[48]

However, this point must be qualified. First, the very need for such viewer training presupposes the recalcitrance, even the resistance, of the distracted subject, and Lichtenstein does not merely reproduce this disciplining in any case. The viewer of a Lichtenstein painting is hardly one with the fighter pilot, the stylish consumer, or even the reader of comic books devoted to such figures; again, Lichtenstein renders them often comical and sometimes preposterous, and we 'don't take them seriously'. As for the paintings of products, not only does Lichtenstein efface the brand names of his sources, but, more importantly, he often breaks down the cliché of the image. For example, however iconic they might appear, *Golf Ball* (1962) and *Tire* are also quite abstract, and *Turkey* (1961) and *Standing Rib* (fig.18), say, are more shapeless blobs than 'crystallized symbols'. Here pictorial schema are loosened from referential grounding and brand recognition alike.

Second, in several paintings of the early 1960s Lichtenstein places his figures in front of windshields, dashboards, gun sights, and televisual monitors in a way that asks us to compare or 'correlate' the canvas with such surfaces.[49] We can thus measure our own looking against the scanning, tracking, and targeting that such prosthetic screens demand of the subject. However, even as Lichtenstein compares these different surfaces, he hardly conflates them: convergences are intimated, but discrepancies persist. The same is true of the different kinds of image in his work, whether 'screened' or 'scanned' (to borrow a distinction from Hamilton). Clearly, Lichtenstein focuses on the first (print) mode, already somewhat dated in the 1960s, but he also looks to the second (electronic) mode, dominant in our age of the computer, a mode that mixes the visual and the verbal in data that we are trained to see and read at once, precisely to scan. Lichtenstein points to this important shift in semblance and in viewing, yet in doing so he does not elide the differences between them: the contradictions remain for us to consider.

What, finally, of the producing subject? Initially Lichtenstein all but invites the charge that he is neither original nor expressive; at the same time he 'Lichtensteinizes' his sources, as Lobel comments, and works 'to make the comics

FIG.19 | ROY LICHTENSTEIN (1923–1997)
Self-Portrait, 1978
Oil and magna on canvas 177.8 × 137.2cm
Private colection

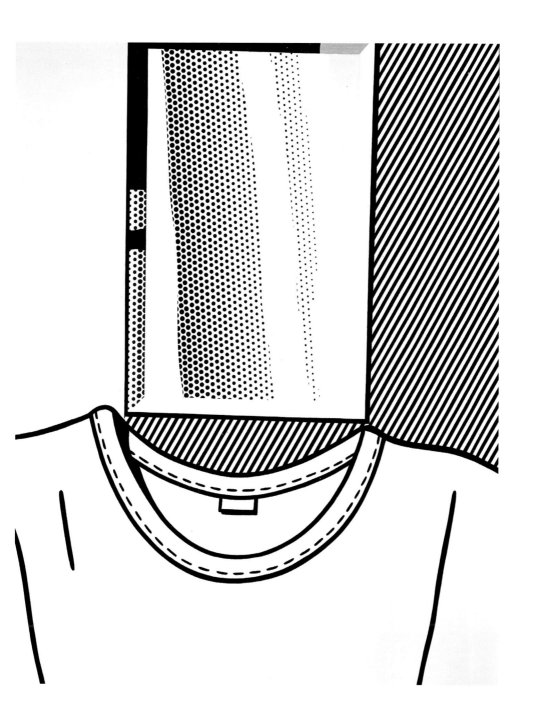

look like *his* images'.[50] (This paradox is condensed in his signing of early Pop paintings with a copyright symbol, which might be construed, equally and oppositely, as an emptying out of invention on his part or as a claiming of all within the image as his own.) Later, too, according to Lobel, Lichtenstein 'oscillates between an erasure of self and an attempt – however conflicted or provisional – to reconstitute a semblance of authorial presence'.[51] Yet this is less a contradiction than it seems, for Lichtenstein creates a signature style out of given forms that appear to preclude such individuation. Moreover, if he did feel a conflict here, it did not disturb him much. 'I am not against industrialization,' Lichtenstein remarked, modestly enough, in 1967, 'but it must leave me something to do.' 'I don't draw a picture in order to reproduce it – I do it in order to recompose it. Nor am I trying to change it as much as possible. I try to make the minimum amount of change.'[52] More than oscillate between signs of erasure and presence, then, Lichtenstein hews closely to this fine line: to adapt images from print media to the demands of advanced painting, in the interest not only of pictorial unity but also of distinctive style, in a way that might affirm these values and, at the same time, register them as threatened and / or transformed by the very forces of mechanical reproduction, commercial design, and mass culture that he otherwise engages. This threat and / or transformation is less an existential dilemma for Lichtenstein than an historical problematic that all Pop artists faced. (Indeed, it is the apparent implacability of this problematic that the relative impersonality of Pop canvases conveys to us today.)

Lichtenstein evokes this threat and / or transformation regarding the producing subject in a distinctive way. It is suggested, for instance, in his mirror paintings of the 1970s, which are mostly blank except for his favourite signs for light and shadow, reflection and refraction; that is to say, these paintings capture the most fleeting of phenomena in the most fixed of representations – his stereotyped dots, lines, and colours. In *Self-Portrait* (fig.19) the self in question is represented only by a t-shirt *sans* a body or a head (which is replaced by a mirror); as a result, the painting is sometimes taken as a portrait of 'the death of the artist'.[53] Yet if such is the case, it is a comical representation of this 'erasure of the self': a self-portrait of the downtown artist in a cheap shirt who, like a vampire, feeds on other images but is

[38]

unable to project his own. In a light manner typical of Lichtenstein, the threat to the subject is at once presented and parodied.

Parody is indeed the distinctive way that Lichtenstein performs and parries such threats. 'In parody there is the implication of the perverse,' Lichtenstein stated in a 1964 conversation (that included Claes Oldenburg and Warhol), but not necessarily the implication of the cynical: 'The things that I have apparently parodied I actually admire.'[54] This perverse admiration is clear enough in his early parodies of Paul Cézanne, Picasso, Matisse, Mondrian, and other modernist masters; at the same time he processes these predecessors through his own emergent style. Different effects are thus produced at the same time. On the one hand, Lichtenstein shows how these master styles have hardened into clichés. On the other hand, as Oldenburg added in the same 1964 conversation, 'a parody is not the same thing as a satire'; rather, it is 'a kind of imitation … [that] puts the imitated work in a new context,' and this displacement can reanimate these styles, too, and individuate Lichtenstein artistically in the process.[55] In short, as with the reification of signs discussed above, he does not simply submit to the styles that he entertains; rather, Lichtenstein finds multiple options – for the artist and the viewer alike – within this array. At the very least, his work helps to free us from two automatic habits: obeisance to high art on the one hand and obedience to mass culture on the other.

BIBLIOGRAPHY

ADORNO 1997
Theodor W. Adorno, *Aesthetic Theory*, (trans. Robert Hullot-Kentor), Minneapolis, 1997

ALLOWAY 1967
Lawrence Alloway, 'Roy Lichtenstein's Period Style: From the Thirties to the Sixties and Back', *Arts Magazine*, vol.42, no.1, September-October 1967, pp.24–9

BADER 2009
Graham Bader (ed.), *Roy Lichtenstein*, Cambridge, MA, 2009

BADER 2010
Graham Bader, *Hall of Mirrors: Roy Lichtenstein and the Face of Painting in the 1960s*, Cambridge, MA, 2010

BARTHES 1977
Roland Barthes, *Roland Barthes by Roland Barthes*, (trans. Richard Howard), New York, 1977

BAUDRILLARD 1981
Jean Baudrillard, *For a Critique of the Political Economy of the Sign* (1972), (trans. Charles Levin), St Louis, 1981

BENJAMIN 1978
Walter Benjamin, 'Paris, Capital of the Nineteenth Century', in *Reflections*, Peter Demetz (ed.) and Edmund Jephcott (trans.), New York, 1978, pp.146–62

BOIS 1990
Yve-Alain Bois, 'Kahnweiler's Lesson', in *Painting as Model*, Cambridge, MA, 1990, pp.65–97

BUCHLOH 1994
Benjamin H.D. Buchloh, 'Residual Resemblance:

Three Notes on the Ends of Portraiture', in *Face-Off: The Portrait in Recent Art*, Melissa Feldman (ed.), Philadelphia, 1994, pp.53–69

BUCHLOH 2000
Benjamin H.D. Buchloh, 'Parody and Appropriation in Francis Picabia, Pop, and Sigmar Polke' (1982), in *Neo-Avantgarde and Culture Industry: Essays on European and American Art from 1955 to 1975*, Cambridge, MA, 2000

BÜRGER 1984
Peter Bürger, *Theory of the Avant-Garde* (1974), (trans. Michael Shaw), Manchester, 1984

COPLANS 1967
John Coplans, 'Talking with Roy Lichtenstein', *Artforum*, vol.9, May 1967, pp.34–9

COPLANS 1972
John Coplans (ed.), *Roy Lichtenstein*, New York, 1972

FOSTER 2003
Hal Foster, 'Dada Mime', *October 105*, Summer 2003, no.105, pp.166–76

FRIED 1967
Michael Fried, 'Art and Objecthood', *Artforum*, vol.5, June 1967, pp.12–23

GLASER 1966
Bruce Glaser, 'Oldenburg, Lichtenstein, Warhol: A Discussion', *Artforum*, vol.4, February 1966, pp.20–4

GOMBRICH 1960
Ernst Gombrich, *Art and Illusion: A Study in the Psychology of Pictorial Representation*, Princeton, NJ, 1960

GOMBRICH 1986
Ernst Gombrich, *Aby Warburg: An Intellectual Biography*, Chicago, 1986

HAMILTON 1982
Richard Hamilton, *Collected Words: 1953–1982*, London, 1982

HERBERT 1979
Robert L. Herbert, 'Method and Meaning in Monet', *Art in America*, vol.67, September 1979, pp.90–108

HUMLEBÆK 2003
Michael Juul Holm *et al.*, *Roy Lichtenstein: All About Art*, Louisiana Museum of Modern Art, Humlebæk, 2003

JAMESON 1993
Fredric Jameson, *Postmodernism, or The Cultural Logic of Late Capitalism*, Durham, NC, 1993

KAHNWEILER 1948
Daniel Henry Kahnweiler, 'Negro Art and Cubism', *Présence africaine 3*, 1948, pp.367–77

KAHNWEILER 1949
Daniel Henry Kahnweiler, 'Preface', in *The Sculptures of Picasso*, Brassaï (photography) and A.D.B. Sylvester (trans.), London, 1949

KEPES 1944
Gyorgy Kepes, *Language of Vision*, Chicago, 1944

KRAUSS 1998
Rosalind Krauss, *The Picasso Papers*, New York, 1998

LOBEL 2002
Michael Lobel, *Image Duplicator: Roy Lichtenstein and the Emergence of Pop Art*, New Haven, 2002

LOS ANGELES, CHICAGO AND NEW YORK 1993
David Deitcher, 'The Unsentimental Education: The Professionalization of the American Artist', in *Hand-Painted Pop: American Art in Transition 1955–62*, Russell Ferguson (ed.), Museum of Contemporary Art, Los Angeles, Chicago Museum of Contemporary Art, Whitney Museum of American Art, New York, 1993, pp.95–118

MADOFF 1997
Stephen Henry Madoff, *Pop Art: A Critical History*, Berkeley, 1997

MADRID 2007
Jack Cowart (ed.), *Roy Lichtenstein: Beginning to End*, Fundación Juan March, Madrid, 2007

MALRAUX 1978
André Malraux, *The Voices of Silence*, (trans. Stuart Gilbert), Princeton, NJ, 1978

MARX 1964
Karl Marx, 'A Contribution to the Critique of Hegel's Philosophy of Right, Introduction' (1844), in *Karl Marx: Early Writings*, T.B. Bottomore (ed. and trans.), New York, 1964, pp.43–59

MCCLOUD 1994
Scott McCloud, *Understanding Comics*, New York, 1994

MCLUHAN 1970
Herbert Marshall McLuhan, *From Cliché to Archetype*, New York, 1970

MULVEY 1989
Laura Mulvey, 'Visual Pleasure and Narrative Cinema' (1975), in *Visual and Other Pleasures*, Bloomington, 1989

NEW YORK, CHICAGO AND LOS ANGELES 1991
Kirk Varnedoe and Adam Gopnik, *High & Low: Modern Art & Popular Culture*, Museum of Modern Art, New York, The Art Institute of Chicago, Museum of Contemporary Art, Los Angeles, 1991

SOLOMON 1966
Alan Solomon, 'Conversation with Lichtenstein', *Fantazaria*, vol.1, no.2, July-August 1966, pp.36–42

STEINBERG 1972
Leo Steinberg, 'The Algerian Women and Picasso

at Large', in *Other Criteria: Confrontations with Twentieth-Century Art*, New York, 1972

SWENSON 1963
Gene Swenson, 'What is Pop art?, Interviews with Eight Painters, Part I', *ARTnews*, vol.62, no.7, November 1963

SYLVESTER 2001
David Sylvester, *Interviews with American Artists*, New Haven, 2001

WALDMAN 1993
Diane Waldman, *Roy Lichtenstein*, New York, 1993

WARBURG 1999
Aby Warburg, *The Renewal of Pagan Antiquity: Contributions to the Cultural History of the European Renaissance*, (trans. David Britt), Los Angeles, 1999

WEBER 2005
Samuel Weber, *Targets of Opportunity: On the Militarization of Thinking*, New York, 2005

NOTES & REFERENCES

1. Hamilton 1982, pp.252, 254. This was indeed the case; for example, Lichtenstein first encountered Abstract Expressionist painting in art publications.

2. John Jones, 'Tape-recorded Interview with Roy Lichtenstein, October 5, 1965, 10:00a.m.', in Bader 2009, p.22. In the same conversation Lichtenstein describes his parody as 'a misconstrued picture of a picture'. 'A Picasso has become a kind of popular object,' Lichtenstein remarked in 1967; 'one has the feeling there should be a reproduction of Picasso in every home' (Coplans 1967, repr. Madoff 1997, p.201). His parodies of other modernist masters like Piet Mondrian, Henri Matisse, Joan Miró, and Fernand Léger suggest much the same status of cliché, more on which below.

3. It might be argued that Neo-Impressionist divisionism, with which Lichtenstein aligns his own work, already made this point. There is a hardening of line and colour in Picasso, too, as early as 1915, and certainly in his Synthetic Cubist work, which Lichtenstein once described as 'a picture of a collage' (Sylvester 2001, p.233). Rosalind Krauss argues that this hardening is a symptomatic reaction to the penetration of photography into art practice around Picasso at this time (Krauss 1998). On the quasi-mechanical aspect in Monet, see Herbert 1979.

4. The 'Explosions' emerged at a moment when shape, as a shared property of painting and sculpture, was much disputed, and when some art works became difficult to distinguish from mere objects (I adopt the terms of the celebrated essay Fried 1967). Here Lichtenstein confounds these oppositions: the 'Explosions' offer shapes that are neither painting nor sculpture, and, though they defeat objecthood, it is not obvious that they do so in the name of art, so insistent is their connection to comic book signs.

5. John Jones, 'Tape-recorded Interview with Roy Lichtenstein, October 5, 1965, 10:00a.m.', in Bader 2009, p.18; Solomon 1966 (repr. Coplans 1972, p.67).

6. Solomon 1966 (repr. Coplans 1972, pp.66–7); Swenson 1963 (repr. Madoff 1997, p.107).

7. This strategy runs deep in the history of the avant-garde: 'Art is modern art through mimesis of the hardened and alienated,' Theodor Adorno writes in 1970. 'Baudelaire neither railed against nor portrayed reification; he protested against it in the experience of its archetypes' (Adorno 1997, p.21). On this strategy see Foster 2003.

8. Solomon 1966 (repr. Coplans 1972, p.85); Coplans 1967 (repr. Madoff 1997, p.199); Waldman 1993, p.26. In 1966 Lichtenstein produced several land and seascapes involving Plexiglas, metal, motors, lamps, and a shimmery plastic called Rowlux.

9. John Coplans, 'Interview: Roy Lichtenstein', in Coplans 1972 (repr. Bader 2009, p.33). On this series also see Alloway 1967 (repr. Coplans 1972). Alloway notes that Art Deco became a fad in the 1960s, but Lichtenstein is interested in its status as cliché more than as kitsch or camp.

10. See my 'Pop Pygmalion', in Bader 2009. Like his later painting, his sculpture tends to be

overlooked because it is taken to be derivative or repetitive of his breakthrough work; obviously, that is not my view.

11. For example, his 1967 modular paintings contain design imagery à la Léger, and in 1975 Lichtenstein produced several paintings after Le Corbusier and Amédée Ozenfant. His neo-Deco paintings were inspired in part by motifs at Radio City Music Hall, New York. Relevant here is his own background in design: in the 1950s in Cleveland Lichtenstein worked intermittently as an engineering draftsman at Republic Steel and for Hickok Electrical Instrument Company; he also decorated display windows for Halle's department store and made models for an architecture firm. See the excellent chronology compiled by Clare Bell (Madrid 2007) and in other Lichtenstein catalogues.

12. Benjamin 1978, p.155.

13. At some point Lichtenstein wrote out a list of such utterances: 'Thwack, Thung, Ratat, Varoom, Pling, Beeow…' (see Humlebæk 2003, p.29). Onomatopoeic terms are often mistaken for the most natural of words; like Ed Ruscha, Lichtenstein suggests that they are conventional in their own way – and, at least in the context of comics, commodified as well.

14. Hamilton 1982, p.252.

15. See Malraux 1978. Lichtenstein produced several studios and interiors after Matisse in the 1990s, but they are less reprises of his art à la Matisse than arrangements of his art (and others) as modish décor.

16. These propositions can be extracted, respectively, from Bürger 1984 and Baudrillard 1981.

17. Allan Kaprow quoted in Avis Berman, 'The Transformations of Roy Lichtenstein: An Oral History', in Humlebæk 2003, p.126.

18. Sylvester 2001, pp.222–3.

19. Ibid., pp.226–7. Lichtenstein did not classicise his commercial images either (as Le Corbusier and Léger were wont to do); rather, he suggested how classical idioms – from columns to the criterion of compositional unity – had become clichés in their own right, more on which below. This clichéd classicism almost reads as a riposte to postmodern style before the fact.

20. Coplans 1967 (repr. Madoff 1997, p.201). In his 1966 conversation with Sylvester, Lichtenstein implies that cartoonists were indeed informed in this way. On the modernist sophistication of the comics, see McCloud 1994.

21. Madrid 2007, pp.118–19.

22. Coplans 1967 (repr. Madoff 1997, p.199).

23. In this desire to compete with spectacle, there is a relation to Léger more important than any stylistic connection. In this move 'from cliché to archetype', there is also a relation to McLuhan, who published a text with this title in 1970 (McLuhan 1970).

24. Lichtenstein is again close here to Ed Ruscha, too. This defamiliarisation places both, unexpectedly, in the lineage of Russian formalism.

25. Gombrich 1960, p.42. Michael Lobel discusses his possible influence on Lichtenstein in Lobel 2002, pp.113–17.

26. Krauss 1998, passim, and Lobel 2002, pp.148–50.

27. Waldman 1993, p.28. The dots are the stuff sometimes of his figures (or faces), sometimes of his grounds, and sometimes of both. Lichtenstein also activates this semiotic dimension in his first Pop objects: though already three-dimensional, his heads and cups are also covered with dots and stripes that signify the modelling of an object in light and shadow. The redundancy of these signs for volume and depth further underscores their conventional status.

28. Lichtenstein sometimes points to his differential way of working, as he does here: 'My emphasis was in forming the relationship of mark-to-mark' (Lichtenstein, 'A Review of My Work Since 1961', in Bader 2009, p.60). Or again here: 'Every mark you make, every line you put down, can't bear any relationships to representation or representational space at the moment it's being put down' (Waldman 1993, p.26).

29. Waldman 1993, p.26. There is a related wresting of the creative out of the commodified in his onomatopoeiac terms.

30. Kahnweiler 1949. Also see Kahnweiler 1948. Yve-Alain Bois explicates the semiotic dimension in Cubism brilliantly (Bois 1990), as does Rosalind Krauss in Krauss 1998 and other texts, but Lichtenstein had already explored this dimension in his art.

31. While, as Krauss argues, Picasso was reactive about abstraction and photography, Lichtenstein embraced both (Krauss 1998, pp.141–54).

32. Sylvester 2001, p.231. 'I am more interested,' Lichtenstein commented in 1971, 'in making a new meaning of an old meaning' (Waldman 1993, p.26).

33. As noted at the outset, Lichtenstein layers manual and mechanical procedures in a way that mitigates reification. Other doubles in his work might have a similar effect, including some not mentioned above, such as affective content verses cool technique, visual impact versus narrative duration, and pictorial singularity versus sculptural mutability of perspective.

34. Lichtenstein quoted in Alloway 1967 (repr. Coplans 1972, p.145); Lichtenstein, 'A Review of My Work Since 1961', in Bader 2009, p.66. On the other hand, as Alloway notes, the revival of Art Deco in the 1960s made it 'visible, even

conspicuous again'. Lichtenstein directs his parodies less at the original styles than at what 'new contexts' have done to them. In the process historical insight might be gleaned, as Alloway intimates here: 'The forms of the thirties are symbols of an antique period with a naive ideal of a modernity discontinuous with our own' (Coplans 1972, p.145).

35. Steinberg 1972, p.128.

36. Ernst Gombrich discusses this fascination in Gombrich 1986, pp.105–27. See the relevant papers collected in Warburg 1999.

37. Marx 1964, p.47 (translation modified).

38. See Lobel 2002, pp.136–44. Laura Mulvey argues that such Hollywood cinema aligns woman, surface, screen, and spectacle (Mulvey 1989).

39. Coplans 1967 (repr. Madoff 1997, p.202). Lichtenstein continues: 'They put their lips on in a certain shape and do their hair to resemble a certain ideal. There is an interaction that is very intriguing. I've always wanted to make up someone as a cartoon…'

40. Swenson 1963 (repr. Madoff 1997, p.109). 'What liberates metaphor, symbol, emblem from poetic mania, what manifests its power of subversion,' Roland Barthes writes, 'is the preposterous' (Barthes 1977, p.81).

41. This key comment is as follows: 'What I do is form, whereas the comic strip is not formed in the sense I'm using the word; the comics have shapes, but there has been no effort to make them intensely unified. The purpose is different, one intends to depict and I intend to unify. And my work is actually different from comic strips in that every mark is really in a different place, however slight the difference seems to some. This difference is often not great, but it is crucial' (Lichtenstein in Swenson 1963, repr. Madoff 1997, p.108). In similar fashion Lichtenstein

remarked to Coplans in 1967: 'I don't draw a picture in order to reproduce it – I do it in order to recompose it. Nor am I trying to change it as much as possible. I try to make the minimum amount of change' (Coplans 1967, repr. Madoff 1997, p.198).

42. David Deitcher discusses these connections in Los Angeles, Chicago and New York 1993, as does Lobel 2002.

43. This association is implicit elsewhere in other modernist art, as Deitcher points out; think, for example, of how Moholy-Nagy developed his idea of 'the new vision', produced by the spread of photography and film in the 1920s, into a pedagogy of design in his 'New Bauhaus' in Chicago in the 1940s. These ideas were in turn elaborated by the Moholy associate Gyorgy Kepes in Kepes 1944 and other texts, which Sherman read closely. This continuum between 'art vision' and 'machine vision' is a particular concern of the work of Paul Virilio.

44. This aggressivity has become patent in our video-gaming present.

45. Swenson 1963 (repr. Madoff 1997, p.108).

46. Sylvester 2001, p.224. Also see Lobel 2002, pp.49–50.

47. Solomon 1966 (repr. Coplans 1972, p.67).

48. On targeting see Weber 2005.

49. Lobel 2002, p.120.

50. Ibid., pp.42–55, here p.47. On the other hand, Kirk Varnedoe and Adam Gopnik claimed that his early paintings make 'the comic images more like the comics than the comics were themselves' (New York, Chicago and Los Angeles 1991, p.199). Sylvester suggested much the same thing already in 1965.

51. Lobel 2002, p.73.

52. Coplans 1967 (repr. Madoff 1997, p.198).

53. See Buchloh 1994. Graham Bader reads these mirror paintings as forms of self-presence realised through self-negation, in Bader 2010.

54. Glaser 1966 (repr. Madoff 1997, p.145; the conversation was first presented on the radio in 1964). Here I disagree in part with Buchloh, who sees such parody 'as a mode of ultimate complicity and secret reconciliation' (Buchloh 2000, p.353). Certainly there is no 'transgression of the code' in Lichtenstein, but a space of difference is also opened up (Buchloh 2000, p.363).

55. However, this is less the case when these same masters begin to flood his work in the late 1970s; indeed, in his late still lifes and studio scenes Lichtenstein often lapses into the eclecticism of pastiche, which, in its mix of styles and signatures, is styleless, even subjectless, in implication. On the difference between parody and pastiche in this respect, see Jameson 1993.